SHARE YOUR BEST WISHES HERE!

T0413435

FLORIDA BABY

A SUNSHINE STATE BABY'S BOOK OF FIRSTS

Written & Illustrated by
Allison Dugas Behan

To James

Copyright © 2024
By Allison Dugas Behan
All rights reserved

The word "Pelican" and the depiction of a pelican are trademarks of Arcadia Publishing Company Inc. and are registered in the U.S. Patent and Trademark Office.

ISBN 9781455627776

Printed in China
Published by Pelican Publishing
New Orleans, LA
www.pelicanpub.com

WELCOME

NAME

BIRTHDAY

FIRST PICTURE

MY FAMILY TREE

FOOTPRINTS

HANDPRINTS

MY FAMILY

ALL THE JUICY DETAILS

DATE

TIME

HOSPITAL

WEIGHT

LENGTH

HOME SWEET HOME

MY FIRST ADDRESS

1 MONTH

MILESTONES & FAVORITES

2 MONTHS

MILESTONES & FAVORITES

2 MONTHS PICTURE

1 MONTH PICTURE

3
MONTHS

MILESTONES & FAVORITES

4 MONTHS PICTURE

3 MONTHS PICTURE

4 MONTHS

MILESTONES & FAVORITES

MONTHS PICTURE

6
MONTHS

MILESTONES & FAVORITES

5 MONTHS

MILESTONES & FAVORITES

MONTHS PICTURE

7
MONTHS PICTURE

7
MONTHS

MILESTONES & FAVORITES

8 MONTHS

MILESTONES & FAVORITES

8
MONTHS PICTURE

9 MONTHS

MILESTONES & FAVORITES

10
MONTHS PICTURE

9
MONTHS PICTURE

10 MONTHS

MILESTONES & FAVORITES

11
MONTHS
MILESTONES & FAVORITES

12
MONTHS PICTURE

11
MONTHS PICTURE

12
MONTHS
MILESTONES & FAVORITES

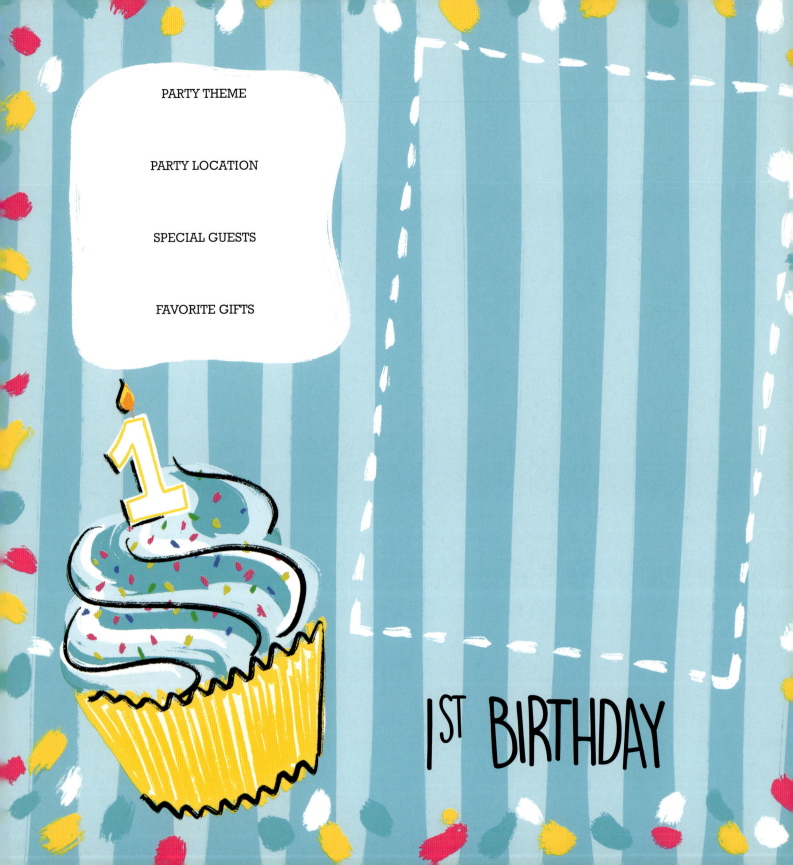

PARTY THEME

PARTY LOCATION

SPECIAL GUESTS

FAVORITE GIFTS

1ST BIRTHDAY

2ND BIRTHDAY

PARTY THEME

SPECIAL GUESTS

PARTY LOCATION

FAVORITE GIFTS

TRYING ALL THE

YUMMY FOOD!

FIRST
ORANGE JUICE

DATE

WHO MADE IT

MY REACTION

FIRST GATOR BITES

DATE WHO MADE THEM

MY REACTION

FIRST
KEY LIME PIE

DATE

WHO MADE IT

MY REACTION

FIRST STRAWBERRY SHORTCAKE

DATE

WHO MADE IT

MY REACTION

FIRST SEAFOOD

DATE

TYPE OF SEAFOOD

WHO MADE IT

MY REACTION

FIRST CUBAN SANDWICH

DATE

WHO MADE IT

MY REACTION

FIRST ACTIVITIES

AND EVENTS!

FIRST FOOTBALL GAME

DATE

PLACE

TEAMS

FINAL SCORE

FIRST BASKETBALL GAME

DATE

PLACE

TEAMS

FINAL SCORE

GO!

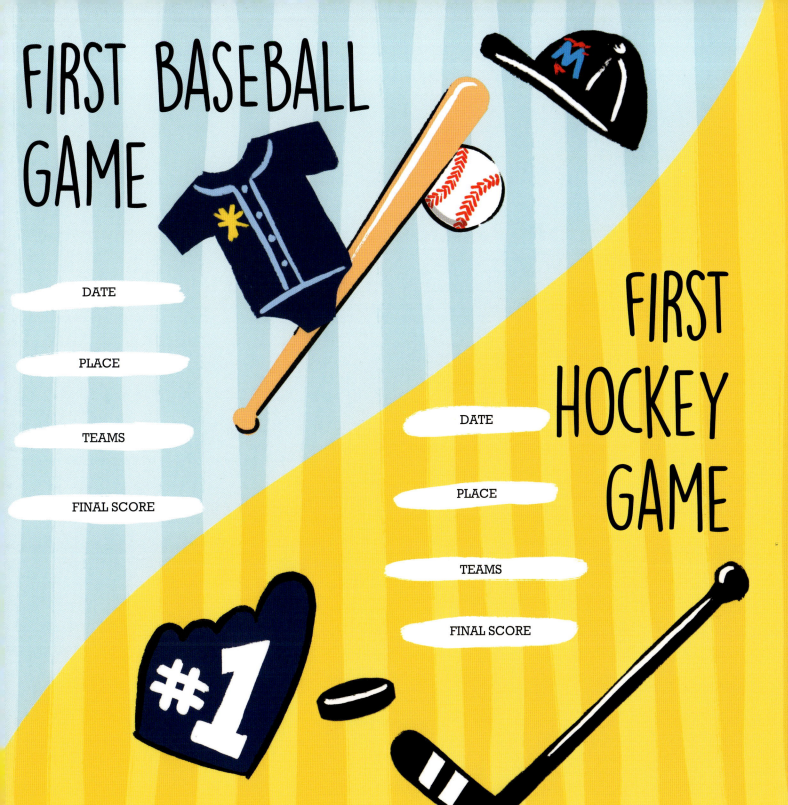

FIRST BASEBALL GAME

DATE

PLACE

TEAMS

FINAL SCORE

FIRST HOCKEY GAME

DATE

PLACE

TEAMS

FINAL SCORE

#1

FIRST THEME PARK

THEME PARK NAME

DATE

PEOPLE WITH ME

FAVORITE RIDE

FAVORITE CHARACTER

FAVORITE SNACK

FAVORITE SHOW

FIRST
ZOO TRIP

DATE

ZOO NAME

PEOPLE WITH ME

FAVORITE ANIMAL

FIRST
AQUARIUM TRIP

DATE

AQUARIUM NAME

PEOPLE WITH ME

FAVORITE ANIMAL

FIRST MUSEUM

DATE

MUSEUM NAME

FAVORITE EXHIBIT

PEOPLE WITH ME

FIRST VISIT TO THE KENNEDY SPACE CENTER

DATE

MY CO-ASTRONAUTS

FAVORITE ACTIVITY

FIRST DAYTONA 500

DATE

MY PIT CREW

WHO WON

MY REACTION

WHO TOOK ME

FIRST FISHING TRIP

DATE

FISHING BUDDIES

LOCATION

WHAT I CAUGHT

FIRST BEACH TRIP

DATE

LOCATION

MY BEACH CREW

MY FAVORITE ACTIVITY

FIRST STATE PARK

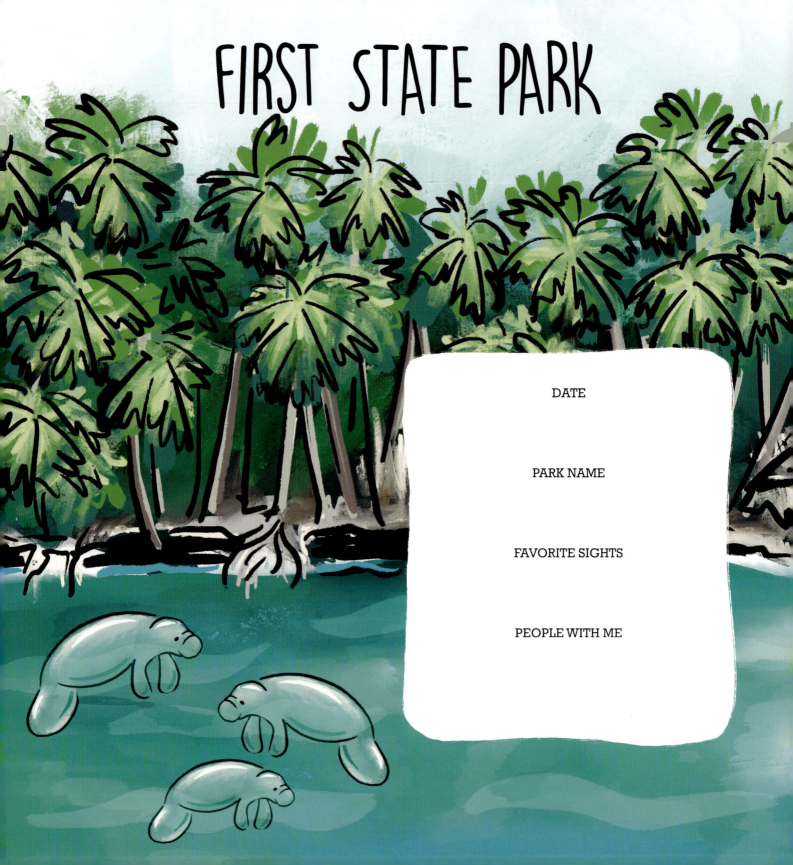

DATE

PARK NAME

FAVORITE SIGHTS

PEOPLE WITH ME

FIRST HOLIDAYS

EASTER

DATE

FAVORITE TREAT

WHERE I CELEBRATED

FAMILY WITH ME

THANKSGIVING

DATE

FAVORITE FOOD

WHERE I CELEBRATED

FAMILY WITH ME

4TH OF JULY

YEAR

FAVORITE TREAT

WHERE I CELEBRATED

FAMILY WITH ME

CHRISTMAS

DATE

FAVORITE GIFT

WHERE I CELEBRATED

FAMILY WITH ME

HALLOWEEN

DATE

FAVORITE TREAT

TRICK-OR-TREAT SPOT

MY COSTUME

NEW YEAR'S

DATE

HOW I CELEBRATED

WHERE I CELEBRATED

FAMILY WITH ME

ALL THE LITTLE EXTRAS

FIRST SMILE

DATE

FIRST LAUGH

DATE

FIRST ROLL OVER

DATE

FIRST CRAWL

DATE

FIRST TIME SITTING UP

DATE

FIRST STEPS

DATE

FIRST TIME I WALKED

DATE

FIRST WORD

DATE

FAVORITE SONG

FAVORITE FOOD

FAVORITE TV SHOW

FAVORITE TOY